Images of America
Sackets Harbor

IMAGES of America

SACKETS HARBOR

Robert E. and Jeannie I. Brennan

ARCADIA

Copyright © 2000 by Robert E. and Jeannie I. Brennan.
ISBN 0-7385-0285-5

First printed in 2000.
Reprinted in 2001, 2003.

Published by Arcadia Publishing,
an imprint of Tempus Publishing, Inc.
2A Cumberland Street
Charleston, SC 29401

Printed in Great Britain.

Library of Congress Catalog Card Number: 99-069482

For all general information contact Arcadia Publishing at:
Telephone 843-853-2070
Fax 843-853-0044
E-Mail sales@arcadiapublishing.com

For customer service and orders:
Toll-Free 1-888-313-2665

Visit us on the internet at http://www.arcadiaimages.com

Contents

	Acknowledgments	6
	Introduction	7
1.	The War of 1812	9
2.	The Harbor	25
3.	People, Places, and Events	41
4.	Downtown	69
5	Village Homes	79
6.	Houses of Worship	89
7.	Madison Barracks	95

Acknowledgments

Information used in this publication came from the research files of Robert and Jeannie Brennan, lifelong residents of the village. Images and text are from our historical records archive and postcard and photographic collections. These files were compiled over 20 years of collecting postcards, photographs, and ephemerons about the village of Sackets Harbor and Madison Barracks. Additional research was done using the microfilm of the *Watertown Daily Times*, which is owned and operated by John B. Johnson, and numerous county histories by Childs, Emerson, Everts, Haddock, and Hough.

A special thanks must be extended to our daughter Constance Brennan Barone, who suggested the publication, encouraged the efforts, and assisted in preparing the captions and introduction.

We also wish to thank the following, who allowed us to borrow images from their collections: Frances Bible, Charles Bridge, the Jefferson County Historical Society, Earleen Maxon, the Pickering-Beach Museum, Col. Charles Waterhouse, and the U.S. Naval History Center.

We owe a special thank-you to Elise Chan, who undertook the task of proofreading the text and captions.

All royalties from the sale of this book are donated to the Pickering-Beach Museum and the Hay Memorial Library in Sackets Harbor.

—Robert E. and Jeannie I. Brennan
Sackets Harbor, New York

INTRODUCTION

An 1801 publication vividly describes an area that the Native Americans called *Niahoure*:

> At the bottom of this gulf Black River empties, forming a harbor sheltered from the wind and surges of the lake, which, during the prevalence of the southwest winds, roll like those of the ocean. The land on the right or south of this bay is extremely fertile, and is a grove more fresh than can elsewhere be seen. That on the left, i.e., the country that extends to the north of the Bay of Niahoure, as far as the St. Lawrence, and east to the Oswegatchie, is not less fertile, and the colonists begin to vie the settling it.

The Oneida and Onondaga tribes of the Iroquois Nation knew the value of the natural resources along the shores of Lake Ontario in northern New York. They hunted and fished in this region and, long before them, remnants of earlier hunter-gatherer cultures tell the story of the bounty this land and water provided.

After the American Revolution, New England farmers learned of the fertile land and wild game on the shores of Lake Ontario. Land speculator Augustus Sacket purchased large tracts and led the first influx of settlers to the region that surrounded the natural harbor on Black River Bay.

No doubt the smuggling of "pearl and potash" into upper Canada aided the expansion of the village during the enforcement of embargo acts. In 1809, the navy ship *Oneida* was stationed at Sackets Harbor to enforce those laws. Three years later, on June 18, 1812, war was declared. The War of 1812 put Sackets Harbor "on the map." The *Oneida* was the only navy ship on Lake Ontario to oppose the British fleet stationed across the lake at Kingston, Ontario. The land and sea battles, naval operations, and shipbuilding at the harbor, brought prominence to this quiet little settlement.

After the War of 1812, Sackets Harbor, with its commercial trade and shipbuilding, was the North Country's most celebrated and prosperous village. Construction of the military post Madison Barracks began in 1816, generating a postwar economy. The village of Sackets Harbor has always been closely linked with Madison Barracks. For nearly 130 years, the post's army personnel and the local citizens interacted in the daily life of the village, in social activities, and in community projects.

By 1853, the Sackets Harbor & Ellisburg Railroad connected to the Rome-Watertown &

Ogdensburg Railroad, linking overland trade routes with commercial shipping on Lake Ontario. Village prosperity prior to completion of the railroad link was centered on trade and commerce. By the end of the 19th century, merchants and businessmen no longer relied on the lake and rail shipping, but rather on the newly emerging tourism industry.

A school, a newspaper, mills, shops, hotels, and taverns supported a thriving village life, which constantly hovered at a population level of 1,200 residents. Early settlers built their houses of worship in the village, which supported its social and religious needs. The building of the Presbyterian church was soon followed by that of the Episcopal and Methodist churches, while the Catholic church opened in the later part of the 19th century.

Commercial fishing continued to flourish into the early 20th century. Madison Barracks remained a center of activity in the life of the village. At the same time, officers at Madison Barracks created a site for military maneuvers at nearby Pine Camp (now Fort Drum).

A self-sufficient lifestyle continued in Sackets Harbor until the advent of the automobile and World War II. Following the war, shops closed and residents more commonly worked in nearby Watertown, making the village a bedroom community.

The revival of the tourism industry, which had been prominent in the early 1900s, came into its own again in the 1960s. Enterprising individuals foresaw the potential for the village and began a revitalization trend, which continues to the present day. The village has become a mecca for pleasure boating, sports fishing, and relaxation. Numerous restaurants, bed and breakfast establishments, a hotel, and marinas are the center of this rejuvenation. Even the former military post Madison Barracks now offers residential quarters, a marina, and recreational facilities.

In 1977, Sackets Harbor was designated one of fourteen parks administered by the New York State Urban Cultural Park System. This recognition highlights the illustrious history of the battlefields, buildings, and neighborhoods. The New York State Seaway Trail, a 454-mile scenic tourism route from Lake Erie to the St. Lawrence River, passes through the village. The Seaway Trail now makes its headquarters in one of the village's most historic buildings.

Until recently, the village of Sackets Harbor was dubbed "a hidden treasure." Today, its strategic location continues to offer recreation and business opportunities for the future. From military headquarters of the Northern Frontier in the War of 1812 to tourism headquarters of the Seaway Trail Inc., Sackets Harbor continues to play a vital role in northern New York state.

One
THE WAR OF 1812

John Melish's 1816 map of the northern section of the United States shows Sackets Harbor as one of the most important communities.

In 1801, lawyer and land speculator Augustus Sacket purchased a tract of land near Lake Ontario at an auction in the Tontine Coffee House in New York City. As a pioneer of the settlement, he served as the tax collector for the district, the county judge, and the colonel of the militia. In 1809, he disposed of his land holdings. He died in 1827 on a trip from his home in Newburgh to Sackets Harbor.

This 1809 map records the sale by Augustus Sacket of 10-acre blocks to the developers of the village. Today, the layout of the original streets remains unchanged.

Lt. Melancthon Woolsey was stationed at Sackets Harbor in command of the brig *Oneida*, the only American warship on Lake Ontario. On July 19, 1812, the *Oneida* was moored at the harbor's entrance. The offside guns were moved off the ship to be used as a shore battery. Gunners on shore joined in smashing Sir George Prevost's attacking force, driving the British to retreat.

Figure 50. Spar and sail plan of the ONEIDA.

The *Oneida*, built at Oswego, was launched on March 31, 1809 to help enforce the Embargo Act against Great Britain on the Great Lakes. Melanchton T. Woolsey purchased the *Oneida* at auction in 1815 for the U.S. Navy. It was used as a troop transport between Oswego and Sackets Harbor.

Sackets Harbor, located at the eastern end of Lake Ontario, was once called *Niahoure* by the Oneida and Onondaga tribes. Because it is one of the largest harbors on the lake and is located less than 30 miles from Canada, Sackets Harbor became the headquarters for military and naval operations for the northern frontier during the War of 1812.

An 1815 engraving by W. Strickland depicts the naval fleet assembled in the harbor. Navy Point and Fort Tompkins are in the foreground.

Jacob Brown assumed command of the local militia after Augustus Sacket left the village in 1809. In 1813, General Brown took command of the land forces to defend the village in the Second Battle of Sackets Harbor. At the war's end in 1814, Brown was appointed to the newly formed position of commander-in-chief of the American Army.

During the War of 1812, the uniforms of the Foot Artillery Regulars consisted of a trimmed blue coat with artillery emblems on the buttons, a white vest, trousers, and a cocked hat with a tall white feather. One style of infantry uniform consisted of a black coat with red cuffs, blue pantaloons, and a leather cap with a cord and tassel.

At the outbreak of the War of 1812, marine architect and shipbuilder Henry Eckford supervised the building of a naval fleet at Sackets Harbor to defend the northern frontier.

One of the ships constructed for the naval fleet was the *Madison*, a corvette of 593 tons, equipped with 20 guns. It was built by Eckford's work force within 40 days from the cutting of the timbers in the forest to its launching on November 20, 1812.

Figure 83. Draught of corvette proposed by Eckford.

Lt. Rene De Russy, a native of Italy, graduated from West Point in 1812. His first engineering assignment placed him in charge of improving the fortifications surrounding the village of Sackets Harbor.

Fort Virginia, one of the five blockhouses connected by a stockade fence, was built on West Washington Street in 1812. This defense system extended around the perimeter of the village and provided protection for civilians and troops during the War of 1812.

During the War of 1812, oxen were used to haul timbers from the nearby forests for the construction of ships for the U.S. naval fleet. (Print by Col. Charles Waterhouse, Marine Corps, retired.)

During the winter months of 1812—1813, workers labored night and day building bigger and better armed ships to be ready for launching after the spring thaw. Marines from Charleston, South Carolina, served as the guard and defense force at the shipyard at Sackets Harbor. (Print by Col. Charles Waterhouse, Marine Corps, retired.)

In September 1812, Isaac Chauncey was appointed commander of naval forces on Lakes Ontario and Erie. He established his headquarters at Sackets Harbor. He led 14 ships, under the command of Gen. Zebulon Pike, across Lake Ontario to Fort York (Toronto), and captured the site on April 27, 1813.

Comdr. Isaac Chauncey's flagship, the frigate *Superior* was constructed in 80 days at Sackets Harbor. It was laid up in ordinary at the war's end and was covered with a board roof.

In 1813, Oliver Hazard Perry received his "Sacket Harbor schooling" in naval warfare from Isaac Chauncey, commander of the naval forces on Lake Ontario and Lake Erie. Perry is best known for his successful naval career on Lake Erie.

Legend says that the Well House on the old battlefield site sheltered a water well dug by a soldier sentenced to die for an infraction of discipline. The soldier dug a well "fit for the troops of the fort," and was subsequently pardoned.

Gen. Winfield Scott, who was in charge of 7,000 troops, established his headquarters at Sackets Harbor during the War of 1812. His attempt to invade Montreal met defeat at the Battle of Chrysler's Field.

Gen. Leonard Covington, in charge of the American Third Brigade, was killed on November 11, 1813 at the Battle of Chrysler's Field near Cornwall, Ontario. In 1820, his remains were moved from French Mills (Fort Covington) to the Sackets Harbor Military Cemetery.

Gen. Winfield Scott joined Gen. James Wilkinson in the ill-fated attempt to invade Canada by way of the St. Lawrence River.

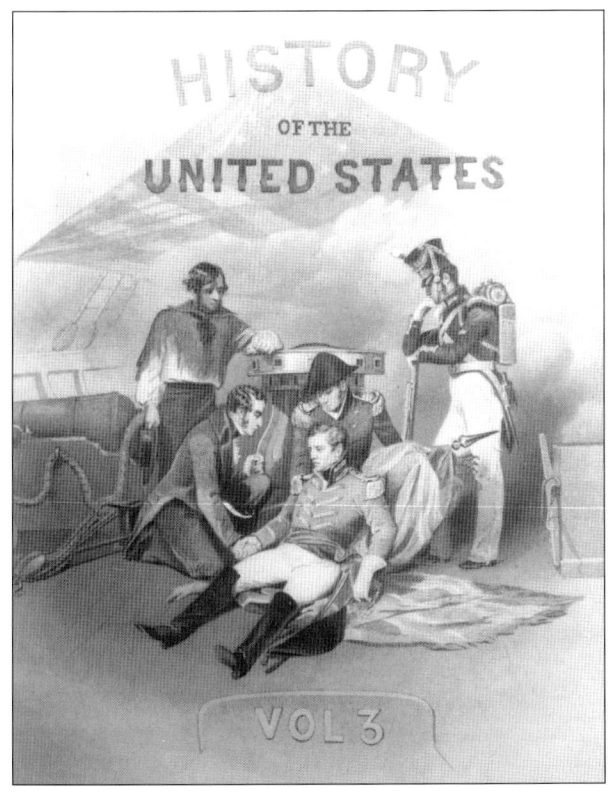

On April 27, 1813, during the invasion of Fort York (Toronto), the British magazine (the building for storing gunpowder) exploded. Gen. Zebulon Pike, commander of the American forces, was mortally wounded when struck by a piece of stone. His remains were returned to Sackets Harbor aboard the corvette *Madison*. Pike is interred in the village's military cemetery.

Equipment needed on board ship is depicted in this artistic tableau.

Each cannon used on board the ships of the naval fleet needed its own gun crew. The attached rope served to position the cannon for reloading and firing.

In December 1814, Henry Eckford was awarded the contract to construct the largest ship in the American navy. Weighing 2,805 tons and measuring 212 feet in length and 56 feet in width, the *New Orleans* was to be equipped with 120 guns. Construction ceased when the Treaty of Ghent, which ended the War of 1812, was signed.

The "Ship House" was constructed by sailing master William Vaughan in the summer of 1815 to protect the unfinished man-of-war *New Orleans*. This early tourist attraction allowed curiosity seekers to explore the ship, entering by ladder and walking the length of the hulk. In 1884, after years of deterioration, the building was sold at auction for $400 to Alfred Wilkinson of Syracuse. One worker, John Oates, was killed while dismantling the ship. Many items were made from the wood, such as canes, pencils, boxes, chairs, tables, and small souvenirs.

This stone monument, near the intersection of state Route 3 and county Route 75, is one of four markers commemorating the route taken by volunteers who carried a 6,000-pound hemp cable 20 miles from Sandy Creek to Sackets Harbor. The cable supplied strands of hemp that were braided to form rigging that outfitted the frigate *Superior*, a ship in the American fleet during the War of 1812.

This 1835 drawing of Sackets Harbor by French artist Jacques Milbert shows familiar landmarks such as the Ship House, Navy Point, Fort Pike, the Presbyterian church, and Fort Tompkins.

Two
THE HARBOR

This view of the harbor was taken from the bell tower of the Presbyterian church at the corner of Broad and Main Streets, c. 1910

The steamer *Ontario* was built by Charles Smyth and Eri Lusher at Sackets Harbor in 1816. It was the first steamboat built on the Great Lakes. The ship measured 110 feet in length, with a 24-foot beam; it weighed 287 tons, was powered by a 21-horsepower engine, and seldom exceeded 5 miles per hour. It was originally scheduled to make weekly trips of 600 miles between Lewiston and Ogdensburg. Later, ten days were required to complete the trip, due to the distance. The fare was $15. The boat operated until 1832, when it was dismantled in Oswego. An article in the *Republican* newspaper of August 17, 1821 noted that "this is by far the most agreeable route from Albany to Niagara Falls."

On Horse Island, located a mile west of Sackets Harbor, is the Horse Island Lighthouse, built in 1831 and rebuilt in 1870. One of the first lighthouse keepers was Capt. Samuel McNitt, hero of the Second Battle of Sackets Harbor in 1813. Manual operation of the lighthouse mechanism ended in 1946. The mechanism was replaced by a radar beacon and navigation light that the U.S. Coast Guard maintains today.

This view of the harbor taken from Ogden Street (now General Smith Drive) shows stacks of wood shingles ready for shipment in the foreground. Dinghies marked the location of buoys where sailboats were moored. The large building on the left shoreline stored the ice harvested from the harbor for use in the village. In the distance is Navy Point with the commandant's and lieutenant's houses. This curve of land forming the harbor became the New York State Naval Militia Training Station in 1915. On the right are the wooden crib and pilings that served as a breakwater at the tip of Navy Point.

The hay scow *Northern Lights* was built at Phelps shipyard in Chaumont for Capt. William Sheeley Sr. Later, the scow was owned by Dexter Dibble of Sackets Harbor and was operated by his sons Spencer and Samuel Dibble, who used it to transport lumber and pulpwood from Canada. In November 1916, while loading gravel at Calf Island, the boat broke its moorings in a storm and ran aground on the gravel bar at Galloups Islands's south harbor.

The Presbyterian Sunday school classes traveled by boat to enjoy a picnic on the shore at Catfish Point, 2.5 miles east of Sackets Harbor. The *Northern Lights*, piloted by the Dibble brothers, provided transportation.

During a gale on August 18, 1908, the schooner *Acacia*, carrying a load of coal from Oswego to Kingston, was blown aground on Bull Rock. Using their sloop *Sarah K*, Spencer and Samuel Dibble managed to save Capt. and Mrs. William Simmons, their two grandchildren, Seaman Arthur West, Robert Watte, and Jeanette Porter.

In 1915, this building on Navy Point, known as the Sail Loft, was remodeled for use as headquarters for the local New York State Naval Militia unit. The building housed the billet (sailors quarters) and officers' rooms on the top floor, the grand assembly and gear rooms on the ground floor, and small boats in the cellar.

On October 2, 1916, the gunboat *Sandoval* arrived at the harbor from Rochester. The vessel, captured from the Spanish during the Spanish-American War, was used as a New York State Naval Militia training ship. After seven years at Rochester, it had been reassigned to its new port at Sackets Harbor.

These tourists enjoyed a day trip on the *Doreen* from Dexter to Campbell's Point by way of Sackets Harbor in 1912. The boat was owned by Charles Morrison of Dexter.

General Electric executives, headed for a summer retreat at the company-owned Association Island, are shown arriving at the Sackets Harbor train station in the 1920s. They were met at the station by Association Island employees and then transported by motorboat launches to the conference center on the island, located 5 miles west of the village in Lake Ontario.

Popular winter sports on the village harbor included ice-skating and snowshoeing. Mary Scroxton (1883–1971), who later became a librarian at the Hay Memorial Library in Sackets Harbor, and her friend pose on their snowshoes.

On a winter's day at the beginning of the 20th century, this lady posed with a skate sail. The sail propelled the ice skater on the harbor or across Black River Bay.

In the early 1900s, private boathouses ringed the harbor. On April 27, 1901, the Crescent Yacht Club selected Sackets Harbor for the headquarters of their organization. The *Zelda*, the 21-foot gaff-rigged sloop seen in this photograph, was one of the registered craft. (Photograph courtesy of the Pickering-Beach Museum.)

In this photograph, the sloop *Zelda* moves away from the camera. The sloop was owned by Sherman Davenport and James MacLaren of Watertown. (Photograph courtesy of the Pickering-Beach Museum.)

In the early 1900s, ferryman Edgar Crapo sailed this small boat daily from Sackets Harbor north to Pillar Point, delivering the mail and passengers. People lined the shores to watch as he performed his delivery duties in the roughest weather.

On June 30 and July 1, 1917, the steamer *Thousand Islander* was docked at the New York Central Railroad Station dock. Passengers, including student officers training at Madison Barracks, are waiting to board the ship for a one-day cruise to Clayton and Alexandria Bay on the St. Lawrence River. The fare for each trip was $1.50. (Photography courtesy of Charles Bridge.)

MOTOR YACHT
UAUTOGO

DAILY FROM

DEXTER

AND

Sacket Harbor

Begins Wednesday, July 25, 1917

DEXTER	Sacket Harbor
LEAVE	ARRIVE
1:00 P. M. 6:00 P. M.	1:45 P. M. 6:45 P. M.
ARRIVE	LEAVE
5:30 P. M. 10:15 P. M.	4:45 P. M. 9:30 P. M.

SUNDAYS
Leave 10 A. M. instead of 1:00 P. M., arriving at Sacket Harbor 10:45 A. M.

This schedule for motor yacht excursions reflects the popular summer recreation opportunities in 1917. The motor yachts were owned by G.S. Jones of Dexter and were piloted by D. Warren.

The Submarine Chaser SC 431, seen moored at Navy Point, was used by the Fourth Division, Third Battalion, New York State Naval Militia, as a training vessel from 1922 to July 19, 1940 in Sackets Harbor. Built by the Matthews Boat Company, Port Clinton, Ohio, it was first transferred to the Coast Guard on October 29, 1919 and used as a boat to intercept illegal traffic on Lake Michigan. Then, in September 1921, it was commissioned to the U.S. Navy. In October 1922, Cmdr. H.J. Angley and a crew from the local naval militia unit transferred the submarine chaser from Chicago to its new port and assignment at Sackets Harbor.

During World War I, the Splinter Fleet (submarine chasers) pursued submarines on the Atlantic Ocean. The crew of the SC 431 poses on the foredeck during a cruise after the war. One member of the crew included Steven Kafka, who was killed when the ship exploded at Sackets Harbor on September 3, 1937.

On June 2, 1919, the former German submarine minelayer UC-97 and accompanying U.S. naval tug *Iroquois* tied up at the New York Central Railroad dock at Sackets Harbor. Hundreds of people drove to the village to tour the two vessels.

In observance of Navy Day on October 21, 1947, the USS *Robin*, a naval training vessel assigned to Sackets Harbor, enters the harbor. Formerly named the YMS *311*, it was officially changed to the *Robin* in connection with navy policy to name auxiliary minesweepers after birds.

During the early 1930s, Canadian Steamship Company freighters brought Canadian pulpwood to Sackets Harbor. These ships nosed into the harbor because they were surrounded by a boom that confined the floating wood.

Pulpwood off-loaded from freighters into the harbor was loaded into trucks from conveyor belts and transported to the Dexter Sulfide Paper Mill in the 1930s.

Rudolph Gowing, pictured on board the *Mermaid II*, was caretaker for the owners of Galloups Island, located 12 miles offshore in Lake Ontario. He operated a charter service from his shipyard at Market Square Park in Sackets Harbor. (Photograph courtesy of Charles Bridge.)

The 40-foot patrol boat CG 40658, stationed at Galloups Island, is seen leaving the harbor. The boat made weekly trips to Sackets Harbor to pick up supplies and mail.

This photograph, taken in 1908 from Gamble's Lumberyard dock, shows W.H. Beebe of New York City at the helm of his speedboat *Flip* leaving the harbor for open water.

This view of the harbor reflects the tranquillity of village life in the 1920s.

Three
PEOPLE, PLACES, AND EVENTS

Members of a family seated on the grassy bank beside the lieutenant's house enjoy the view from Navy Point. Schooners anchored in the harbor were used to transport grain and hay. Madison Barracks is visible in the distance.

This group photograph of schoolchildren was taken from the balcony of Benjamin Scroxton's Tinware store on West Main Street in 1887. In the front row, second from the right, is Fiorello LaGuardia. He began school in Estelle Littlefield's first-grade class. He became mayor of New York City in 1934.

To celebrate the visit by Pres. James Monroe in 1817, the community erected 19 arches decorated with flowers and ribbons over the Stone Bridge on Military Road. A live American eagle perched on the first arch. As Monroe crossed the bridge, the Volunteer Artillery greeted him with a 19-gun salute.

This view of Main Street was taken from Quinn's Hotel prior to 1920. The tallest building on the left is the Eveleigh House, which was destroyed by fire in 1920.

In 1890, bandmaster Achilles LaGuardia, father of New York City Mayor Fiorello LaGuardia, lead the Eleventh U.S. Infantry Regimental Band down West Main Street past the Earl House and Madison Hall. In this photograph taken by W.W. Fairbanks, the band is on its way to the New York Central Railroad Station to meet an incoming army colonel.

On July 24, 1870, the military funeral procession for Lt. John H. Philbrick proceeded down West Main Street to the New York Central Railroad Station. The casket was carried on the evening train for interment in Waterville, Maine, Philbrick's former home. A member of the Presbyterian church, Philbrick was president of the Society of Christian Endeavor and taught Sunday school in Sackets Harbor.

These village residents travel down Main Street in front of the Independent Order of Odd Fellows Hall.

On a summer day in 1911, Bert, Addie, and Julia Hazelwood drive Tonie and Jardie, their gold-dust colored horse team, along West Washington Street. The Augustus Sacket House is visible in the background.

Frank and Emma Westcott, with Aunt Sadie in the backseat, take their first Ford on an outing, stopping in front of Cyrus Webb's home near Bedford Creek (south of Sackets Harbor on Route 3).

After a severe snowstorm these men stand on the corner of Ambrose and West Main Streets to survey the results of the storm. From left to right, they are Jim Crowel, Walt Gurney, unidentified, Sheldon Stratton, and unidentified.

The volunteer firemen extend a fire hose down Main Street, c. 1911, possibly to wash down the street before a special event.

46

On December 15, 1917, soldiers of the Quartermaster Corps stationed at Madison Barracks wielded shovels, alongside a snowplow attached to an army motortruck, at the corner of West Main and Ambrose Streets. Many of these men were from the South and may have had their first experience with snow while stationed at Madison Barracks.

Frank Westcott's Ford garage was located at Market Square Park on West Main Street. The original fire hall is on the right. The Ford touring cars and delivery truck were models in Westcott's inventory.

On Memorial Day 1909, after the annual Decoration Day parade, crowds gather in front of Warner's Garage, located near Market Square Park. (Photograph courtesy of Earleen Maxon.)

Band members prepared to entertain spectators at the Sportsmen's Outing in this early 1900s photograph. Buildings along the east side of lower West Main Street had been rebuilt following a fire in 1889. (Photograph courtesy of Charles Bridge.)

Volunteers firefighters pose with a Silsby steam pumper, purchased in 1887, in front of the Protection Fire Department on West Main Street at Market Square Park. Members are, from left to right, Van Scotter, William Stevenson, Benjamin Scroxton, Jay Wilder, James Lonsdale, George Hamilton, Archibald Burnup, Floyd Morseman, Floyd Parker, Thomas White, Hank Holiday, "Whoopy" Harris, unidentified, Howard Brooks Sr., "Gummy" Gamble, and Robert Graves.

The Sackets Harbor Fire Department members pose for a photograph after participating in a 1906 firemen's parade. They are, from left to right, as follows: (front row) 2nd Asst. Chief John White, Ray Reeves, Chief Frank Westcott, 1st Asst. Chief Sheldon Stratton, Grant Holloway, William Stuckey, and Reverend Hatfield; (back row) Henry Lake, Samuel Dibble, Orrin Boulton, Wilbur McKee, Dr. Merritt F. Phillips, Perl Gamble, William Houghton, Henry Harris, "Gummy" Gamble, and Fred Harris.

Members of the Protection Fire Department No. 1 are pictured with their 1841 Hinman hand pumper and their 1887 Silsby steam pumper. Honorary member Dr. Merritt Phillips is seated in the center of the front row.

This photograph shows part of the crowd who gathered at the Sackets Harbor Battlefield site to witness the dedication of the Sacket Harbor Battle monument in 1913. Some 3,000 people arriving by train, car, and horse-drawn carriage, were met and escorted to the ceremony by soldiers of the Second and Third Battalions of the Third U.S. Infantry, who are seen here standing in formation during the ceremony.

This monument on the War of 1812 battlefield was dedicated by the Northern Frontier Chapter of the Daughters of 1812 on May 29, 1913. It honors those who died in the War of 1812. Franklin Delano Roosevelt, assistant secretary of the U.S. Navy, was one of the dedicatory speakers.

Master Mason James Wilson stands in his yard on Ray Street next to the Union Hotel in June 1879. Masonic meetings were held on the third floor of the Union Hotel. A stained-glass window showing the Masonic symbols can still be seen in the pediment of the building.

West Main Street in the winter of 1910 is cleared for pedestrian traffic. Walter Lee is shown leaving Lane's grocery store.

Schoolchildren march in the May 30, 1914 annual Memorial Day parade down West Main Street to the Eveleigh dock. There, flowers were scattered on the waters of Lake Ontario in honor of deceased sailors.

In this series of three photographs taken in 1914, the volunteer fireman's band is shown leading a military parade along West Main Street.

In the same parade, the New York State Naval Militia company, shown pulling a cannon, is the second unit in the line of march.

The third photograph in this series shows a close-up view of the Naval Militia unit at the corner of Ogden (General Smith Drive) and West Main Streets. (Photograph courtesy of Earleen Maxon.)

On December 17, 1914, rail passenger service was delayed by a severe snowstorm. A railroad rotary snowplow from Watertown is pictured trying to clear the railroad tracks at the corner of Edmund and Ambrose Streets.

A winter storm in the 1930s delayed railroad service to Watertown. A New York Central Railroad rotary plow is shown clearing the cut on Ambrose Street where the rail line passed under West Washington Street. High school students were given the day off from school to help.

In the early 1900s, New York Central locomotives reversed direction by means of a turntable located east of the railroad depot by the harbor's edge. A member of the all-black Twenty-fourth Infantry Regiment stationed at Madison Barracks, is shown waiting to board with other passengers.

On January 29, 1908, the Twenty-third Infantry departs from the New York Central Railroad Station for a tour of duty in the Philippine Islands. The Twenty-third Infantry numbered 859 men.

Rail passenger and freight service were provided by the Carthage, Watertown, & Sackets Harbor Railroad, which opened in 1874. Seven trains a day arrived at the New York Central Railroad Station on the waterfront. Rail service was discontinued in 1949.

Emmet Brooks, a self-employed delivery man, is pictured with his horse and wagon on the platform of the New York Central Railroad Station. For many years, he delivered incoming freight items to the village merchants.

After 75 years of railroad service, New York Central locomotive No. 1919 made its last run from Watertown to Sackets Harbor on May 8, 1949. The crew was greeted by stationmaster Charles Hayden, third from left, and Harold Hovey and Andy Knoff, standing with him.

Neighborhood children watch the demolition of the New York Central railroad bridge on West Washington Street in the summer of 1950. Rail service to the village ceased with the removal of the bridge and the 11 miles of track to Watertown.

The two-story Union School House was built on the corner of Broad and West Washington Streets c. 1840 at a cost of $2,000. The land was donated by Thomas L. Ogden, an early land speculator who also gave land for the cemetery and the village park. In the school, three departments with a faculty of three to five teachers instructed grades 1 through 12. The school was demolished in 1932.

The class of 1919 poses for a graduation picture in front of the west side of Union School. Shown here, from left to right, are Henry Fuller, Miss Dumas, Ethel Keenan, Principal Henry Ceigler, June Gurney, an unidentified teacher, and Denzel Fawdrey.

The Sackets Harbor High School Football Team of 1925 poses on the property where the new school was built three years later, in 1928.

The 1928 Sackets Harbor High School Football Team had a winning season. In games against nine schools, including Watertown, the team scored 229 points versus only 29 points scored by all their opponents. Pictured, from left to right, are the following: (front row) Tom Coe, Pete Fawdrey, Francis Gibson, King Patrick, Dick Phelps, Neil Walton, and Greg McGrath; (middle row) Marsh Stratton, Tom Lawlor, Parker Warren, Abe Chiles, Jim Brennan, Bill Padgett, and Walt Chiles; (back row) Bob Slocum, Rip Rushnell, Tom Huttemann, "Coach" Al Gonzales, Herbert Huttemann, Bernard Major, and Head Coach Kennith Patrick. Team member Barry Major is not shown.

The Sackets Harbor High School girls' basketball team of 1932 completed its season with seven victories and five losses. Pictured here are, from left to right, as follows: (front row) Mary Young, Capt. Kathleen Brennan, and Barbara Evans; (back row) Coach Margaret Houston, Kathleen Gonzales, Eleanor Gowing, Ruth Brimmer, Eloise Gowing, Ethel Phillips and Coach Niles.

The 1910 Sackets Harbor Basketball Team was one of the first organized teams in the area. It did not have a home court. Its first games were played in Lane's Hall, a long, narrow, poorly lit room on West Main Street. Later, the team played in the Odd Fellows Hall, which was also on West Main Street. Team members are, from left to right, as follows: (front row) Harry Thompson and William Hill; (middle row) Ray Whalen, Neil Gilmore, and Robert Ramsey; (back row) Roland Pettit and Romaine Gowing.

The construction of the Sackets Harbor High School on South Broad Street began in 1927. A.M. Marsh, at 91 years old with 20 years as a board of education member, presided at the ground-breaking ceremony. The school was completed in 1928. The first graduating class had two students, Ruth Boulton and Kenneth Patrick.

Organized summer recreation days in the early 1950s gave village schoolchildren a chance to go swimming at the local Wescott Beach State Park or to be creative in the arts. These contestants won prizes in the costume contest; they are, from left to right, Claude Alverson, Constance Brennan, Pamela Cryder, and unidentified.

The 1937 Girl Scout Troop No. 2 poses on the steps of the Presbyterian church at the corner of Broad and East Main Street. Pictured here, from left to right, are as follows: (first row) troop leader Maude Parker Illingworth, Margaret Robertson, Edith Saltzman, Eileen Griffin, Pauline Hayden, Harriet Saltzman, Arlene Stevens, unidentified, Ann Cook, Jacqueline Locklear, assistant leader Lillian Bible, and Caroline McClary; (second row) Geraldine Phillips, Alice Locklear, Eula Ciegler, Sally Stoddard, Wilma Duggan, Roberta Horton, Sally Phillips, Joyce Van Camp, Betty Jean Stevens, and Kathryn Robertson; (third row) Patricia Phillips, Joan Thomas, Margaret Griffin, Mildred McGrath, unidentified, Barbara West, Myrtle Osborne, and Frances Bible; (fourth row) Jean Kafka, Mary Frances Cook, Emily Hodge, Vaughan Gurney, Josephine Stewart, Molly McGrath, Blanche Parker, and Kay Metcalf.

Washington Park, bordered by Dodge Avenue and North Broad Street, was dedicated on May 18, 1932. Mrs. Myron Avery, on the left, and Mrs. Rolla Stoodley, president of the Civic Improvement League, were assisted by, from left to right, Mabel Sherman, Donald Coe, Dorothy Stuckey, Frederick Wardwell, Mary Frances Cook, and Robert Brennan. The entire school, led by the Fifth Field Artillery Band, marched to the site. Mayor Frank Lehman introduced Judge Crandall Phillips of Watertown, who spoke on "Washington the Statesman."

In 1898, Sgt. James Beane of the Ninth U.S. Infantry returned from service in Cuba during the Spanish-American War. He brought back a brindled greyhound, named Cute from Cuba, as a "prisoner of war." This monument is dedicated to the dog. It was placed in the backyard of the Beane homestead on North Broad Street. The phrase "never to be removed" was recorded in Sergeant Beane's will.

Employees of Calavo Inc. celebrate Halloween at the American Legion Post clubhouse located on Ambrose Street. Pictured c. 1947, from left to right, are the following: (first row) unidentified, Leona Phillips, Dorothy West, and Barbara Lynch; (second row) Elizabeth Lawlor, Bea Carpenter, Bertha Osborn, Sadie Fawdry, Agnes Burnup, and Ruth Wicks; (third row) Winifred Bagley, Grace Nance, Denzel Burnup, Beulah Banville, Carolyn Phillips, Isabelle Backus, Georgia Holloway, Gladys West, and two unidentified women; (fourth row) Sarah Graves, Virginia Osborne, Helen Snyder, Verna Leuze, Minnie Shaw, Betty Elliott, Mae Chapman, Hazel Brown, Marion Stanford, Virginia Casario, Nettie Main, Alice Alcombrack, and Kathyrn Harp.

The Civic League's float was part of a parade that celebrated Old Home Week in the 1960s.

An unidentified man presents the color standard to Boy Scout Troop No. 43 during this 1949 Memorial Day parade on West Main Street. Pettit's drugstore and the Samuel Hooker house are in the background. (Photograph courtesy of Charles Bridge.)

Members of the Sackets Harbor Mother's Club posed for this October 26, 1943 photograph, taken at the United Service Organization (USO) club rooms at the Independent Order of Odd Fellows Hall on West Main Street. Members of the club, from left to right, are as follows: (front row) Mrs. Charles Lyon; Mrs. Bernard Orvis; Mrs. Archie Morris; Mrs. Mort Burnup, secretary-treasurer; Mrs. C.G. Phillips, president; Mrs. J.P. May, first vice-president; Ella Thomas, editor; Mrs. R.N. Gates; Mrs. R.G. Goodale; and Mrs. Guy Everett; (back row) Mrs. R.N. McGrath, Charlotte Horton, Mrs. Sheldon Stratton, Mrs. A.G. Hodge, Mrs. Charles Root, Vivian Thomas, Mrs. Harry Krake, Mrs. Leon Brown, Mrs. H.R. Russell, Mrs. P.X. Brennan, Lucy Lee, Mrs. George Hess, Mrs. Lyle Phelps, and Mrs. Henry Major.

A graduate of Sackets Harbor High School, mezzo-soprano Frances L. Bible studied voice at Julliard School of Music in New York City. She joined the New York City Opera Company in 1948. Her career spanned 45 years, during which she performed a repertoire of over 40 roles in operatic literature. Now retired, she resides in Hemet, California.

For four decades, Van Camp's Esso gasoline station and service garage on Broad Street catered to motorists' needs.

Downtown Sackets Harbor after WWII offered a variety of businesses and services.

Four
DOWNTOWN

In the 1866-67 *Business Directory of Jefferson County*, 50 merchants were listed on Main Street between Broad Street and Market Square Park. They offered products from baked goods to wood to hats, "answering the needs and wants" of every inhabitant.

In the 1870s, stores located in the block next to the Eveleigh House included an ice cream parlor, a harness shop, a barber shop, and a flour and feed store.

Known as the Mill House, this limestone building was constructed on the waterfront for Col. Edwin Guthrie, son of Dr. Samuel Guthrie. Built as a distillery, the Mill House had two stories facing Ogden Street and three stories facing the lake. Other owners of the property were early settler Col. Elisha Camp, regional artist Charles Naegle, and novelist Chard Powers Smith.

John Scroxton's Tinware & Stove store was located on West Main Street in 1887. The flagstone sidewalks, cobblestone curbs, and picket fences were common features on Main Street during that time.

This West Main Street building was constructed in 1908 on the site of Madison Hall, which had been destroyed by the fire of 1899. The Independent Order of Odd Fellows building had meeting rooms for its lodge on the second floor. The first floor provided a large hall for public use. Over the years, the building housed graduation exercises, minstrel shows, and one of the first WWII United Service Organization (USO) clubs in the United States. The building is now the Ontario Playhouse.

Masonic Hall (Oldest in N.Y. State), Sackets Harbor, N.Y.

The Union Hotel, referred to as the Masonic Hall, was built in 1817 by Frederick White on the corner of West Main and Ray Streets. Limestone for the hotel was quarried at the nearby village of Chaumont and transported by barge. The hotel Ontario Lodge purchased the hotel in 1865 for Masonic lodge meetings, which were held on the third floor. Formed in 1805, this Masonic lodge is the oldest one in Jefferson County. The building was sold to New York State in 1970 and was scheduled to become the headquarters of Seaway Trail Inc. in 2000.

The Eveleigh House, built by Ambrose H. Dodge, was located on the corner of West Main and Bayard Streets. In 1867, owner William Porter traded his Barrows House to Barney Eveleigh in exchange for a three-masted lake schooner. The hotel was destroyed by fire in 1920.

A coal gas explosion caused the fire that destroyed the Eveleigh House on January 4, 1920. Proprietor Melvin Quinn managed to save two guests: Maude Barber, a local teacher, and Anne Benedict, a Red Cross nurse. Trapped in his room, 81-year-old William Laughlin died. Village firemen received assistance in fighting the fire from soldiers of the Sixty-third Infantry stationed at Madison Barracks and from members of Fire Company No. 2 of Watertown.

The Ontario House, on the corner of West Main and South Broad Streets, was built in 1817 by Judge Elijah Field. In 1868, Richard M. Earl, a native of the village, acquired the hotel, which subsequently became known as the Earl House. After renovations in 1893, officers from Madison Barracks entertained guests at "a supper and dress ball german."

Established in 1834 as the second bank in Jefferson County, the Sackets Harbor Bank was located on the corner of Broad and West Main Streets. This Georgian-style limestone building was built by Gen. W.H. Angell of Clayton. Over the years the building was used as a residence, a tearoom, a dry-cleaning business, and a tavern. In 1987, the Sackets Harbor Historical Society completed rehabilitation of the building for use as its own headquarters and, once again, as a bank.

Built in 1835, this three-story brick building at 110 West Main Street was once a liquor store, a saloon, and a hotel. In 1895, William Bettinger became proprietor of the hotel, which he managed for 25 years. The men in this view are, from left to right, Floyd Parker, two unidentified soldiers, Jay Morseman, Billy Bettinger, Ed Gamble, and "Sport" Goonan.

In 1918, the Gustave Keenan barbershop, the Gladys Whalen Stoddard Tarrymore Tearoom, the Huested photographic studio, and the P.W. Koppenhaver barbershop were all located on lower West Main Street.

In the 1940s, the Freeman Bus Lines operated daily buses from Sackets Harbor to Watertown via Dexter and Brownville. MacIntosh's Soda Fountain store on West Main Street served as the bus stop. Stores located on the opposite side of the street included the Paul Picori bar and restaurant, the Jane Stokes Variety store, the Baxter Hardware store, the Sarvey Meat Market, and the Edward Hotel, now the Tin Pan Galley restaurant.

10-5 LB. PACKAGES

IMPERIAL

MILK & MEAT CEREAL

DOG FOOD

A COOKED FOOD FOR ALL BREEDS OF DOGS & PUPPIES

MANUFACTURED BY

IMPERIAL PET FOODS, INC.

SACKETS HARBOR, N. Y.

The two-and-one-half-story, concrete-and-tile Imperial Biscuit Company factory cost $60,000 to build. Constructed on General Smith Drive (Ogden Street) in 1925, the Imperial Biscuit Company manufactured dog biscuits and fox biscuits in that facility. In operation until 1940, the company received orders from near and far—even as far as Alaska, France, and Norway.

Calavo Inc. of Los Angeles, a firm engaged in the processing and packaging of dried fruits, leased the former Imperial Biscuit Company building in 1946. Dried fruits were shipped to the plant from California. Dates were shipped from the Persian Gulf area. The company ceased operations in July 1981.

In 1990, the former Imperial Biscuit Company building was converted into a three-story hotel. Current owners Murray and John Maxon operate it as the Ontario Place Hotel.

Five
VILLAGE HOMES

Construction of the Sacket Mansion began in 1801, the year Augustus Sacket purchased land in the town of Hounsfield. Located opposite Market Square Park and the harbor, this one-and-a-half story home was completed by 1803. During the War of 1812, the upper level was used as a hospital.

The Camp Mansion was built in 1816 for Col. Elisha Camp, lawyer and resident agent in Sackets Harbor for a group of New York businessmen. Bricks used in the construction were brought from England and transported by boat and ox cart to the village. Located on General Smith Drive, the home overlooks Black River Bay. The home is still owned by the Camp family, the ninth generation of which occupied it in the late 20th century.

In 1804, 18-year-old Elisha Camp, brother-in-law of Augustus Sacket, moved to the North Country. An attorney, Camp was appointed town surveyor in 1807. Until his death in 1866, Camp promoted the community and the surrounding area. His many accomplishments included forming an artillery company in 1811 for the War of 1812, establishing area schools and churches, commissioning the construction of the steamboat *Ontario*, and ordering the digging of Camp's Ditch from Watertown to supply Sackets Harbor with water to power mills.

In 1824, Deacon Jacob Brewster purchased this Georgian-style mansion on Broad Street. He was the direct descendant of William Brewster, the fourth signer of the Mayflower Compact. Jacob Brewster became an elder and active member of the Presbyterian church in Sackets Harbor.

Camp Haven, located on West Main Street, was built in 1816 for Lt. Melancthon Woosley, a commodore in the U.S. Navy during the War of 1812. In 1844, the mansion became the property of the Camp family, who occupied it for 99 years. Col. Walter Camp, world traveler and collector of rare antiques, entertained Lt. Ulysses Grant and his wife, Julia Dent, in this home when Grant was stationed at Madison Barracks.

81

This brick mansion was built in 1839 on the north side of Broad Street for George A. Sacket, son of Augustus Sacket. In 1849, financial problems forced George Sacket to sell his 19-room home. Before leaving, he engraved "G. Sacket Mar. 5, 1849" on a window pane in the east wing.

This Georgian-style mansion was built c. 1832. It stands on the Washington Street lot that was originally occupied by a blockhouse that was built as one of the defenses of Sackets Harbor during the War of 1812. In 1893, Thomas Rankin purchased the home. He was the inventor of the loop-the-loop, which was featured at the Chicago World's Fair.

The Denison House was built in 1836. More than a century later, in 1937, the house, then owned by Mrs. Anderson Wise, underwent extensive renovations. Workmen shown in the photograph are, from left to right, as follows: (front row) Charles Gamble, Percy Gamble, Archie Burnup, Bill Gamble, Ralph Densmore, Gilt Lawrence, Harold Brooks, and Perl Framer; (back row) Mort Burnup, George Prevost, unidentified, Clinton Hodge, Lyle Phelps, and unidentified.

When Mrs. Anderson Wise acquired the Denison property in 1937, she had the mansion extensively rebuilt with the additions that resulted in its present appearance.

This house stands on the north side of the Watertown-Sackets Harbor state highway, about a mile from the village. Built from local brick in 1817, it was the residence of Dr. Samuel Guthrie for more than a quarter of a century. In 1831, Guthrie discovered the use of chloroform for medical purposes. He is also famous for inventing the "percussion pill" that was used to fire a musket, thus revolutionizing the use of firearms.

The Capt. Ralph Godfrey House was built on West Washington Street c. 1844 by Dyer Burnham, a Sackets Harbor lawyer. Captain Godfrey, a Great Lakes sailor, acquired the property in 1866. After retiring from a seafaring lifestyle, Godfrey became janitor of the Union School, a position he held for 20 years.

Capt. William Vaughan, hero of the First Battle of Sackets Harbor, is said to have built this house on East Main Street in 1842. The house is of unique construction, as the side and rear outer walls are of brick while the front is faced with narrow clapboards.

Sailing master Capt. William Vaughan and his wife, Abbey Vaughan, are credited with driving back the British invasion by firing the crucial shot from the cannon that is fondly called the Old Sow on July 19, 1812. The British 32-pound cannonball that was used as ammunition against the attacking ships had been retrieved on the bluff overlooking the British fleet. This shot destroyed the British flagship's mast and caused additional damage, forcing the British to retreat.

Constructed in 1847 by the U.S. government on land known as Navy Point, the Commandant's House is located on what was once the smallest naval base in the world. This imposing three-story brick structure sits on a high cut-limestone foundation. Widow A.H. Metcalf was "ship keeper" of the naval station from 1906 to 1925. At that time, she was the only woman in charge of a U.S. naval station. The navy transferred the station to the New York State Naval Militia in 1915. The State of New York purchased the property in 1954 as part of the developing battlefield site, Sackets Harbor. The Commandant's House, now restored to its pre-Civil War appearance, is maintained by the Thousand Island Park Commission.

Known as the Lieutenant's House, this brick building is adjacent to the Commandant's House on Navy Point. Built in 1848, it was the residence of the captain of the yard. Upon the death of Albert Metcalf, who had been keeper for 22 years, Mrs. Albert Metcalf became the only woman commandant of a U.S. Naval Station in the world. She held this position from 1906 to 1925.

This home is known as the Amos Roberts House. In 1815, Roberts arrived from Stamford, Connecticut, and purchased the building lot from Col. Elisha Camp. Asahel Smith, one of the subsequent owners, was a cabinetmaker. He and his son Albertus Smith built furniture and caskets in the basement of the house.

This home was built on the south side of Ambrose Street in 1842 for William Gladwin, one of the village's leading businessmen. On October 11, 1949, the dwelling was purchased by American Legion Post 1757 to be converted into the headquarters and clubhouse for the organization. On September 30, 1958, the 130-year-old American Legion building was destroyed by fire.

Massachusetts native Joshua Pickering built this residence c. 1816. Pickering's son, Capt. Augustus Pickering, piloted the first commercial ship, the Illinois, into the port of Chicago on June 14, 1834. The Illinois carried 50 barrels of flour, 50 barrels of pork, and 104 North Country migrants destined to settle in the West. Pickering family members and descendants occupied this home from 1817 to 1936. Among them was the Honorable Allen C. Beach, who served as New York State's lieutenant governor (1868-1870) and secretary of state (1878-1880). Amy Beach Ewers, daughter of Olivia Pickering and Allen Beach, gave the house and its contents to the village for use as a museum, known today as the Pickering-Beach Museum.

One of the rooms in the Pickering-Beach Museum exhibits furniture used by both the Pickering and the Beach families during their ownership of the home. An 1803 Constitution mirror, with 14 acorns decorating the molding, hangs above the French card table.

Six
HOUSES OF WORSHIP

In 1846, the second Presbyterian church was built on the corner of East Main and Broad Streets. In 1893, a new tower was constructed to house a set of nine bell chimes that had been donated by Marietta Pickering Hay.

This photograph shows the ruins of the Presbyterian church, which was destroyed in the great fire of April 3, 1899. (Photograph courtesy of Pickering-Beach Museum.)

Organized in 1816, the first Presbyterian church was built on West Washington Street in 1820. Destroyed by fire in 1843, the building was reconstructed on the corner of Broad and East Main Streets. Again destroyed by fire in 1899, a new church was designed for the site by Watertown architect D.D. Kieff. In 1920, the Hay Memorial Library addition was added on the Broad Street side of the building.

The cornerstone for the Christ Episcopal Church was laid with Masonic ceremonies on May 26, 1823. William Waring had made arrangements for construction of the church on an East Main Street lot donated by Frederick White. After Waring died, construction work was suspended and the church was not completed until 1832.

Members of the congregation of the Christ Episcopal Church gather for their annual picnic. This picture showing them on the steps of the church on East Main Street was taken by M.C. Herron. (Photograph courtesy of Charles Bridge.)

St. Andrew's Roman Catholic Church was built in 1886 on the corner of East Main and Woolsey Streets on land donated by retired U.S. Army Sgt. William Ferguson. Soldiers from Madison Barracks assisted with the construction.

A military funeral was held for Cpl. Michael Fennesy in St. Andrew's Catholic Church in 1913. Fennesy, a member of the Third U.S. Infantry stationed at Madison Barracks, was killed on the target range at Camp Perry, Ohio.

In 1927, Fr. James McClure initiated the major interior renovations to St. Andrew's Catholic Church which added a sanctuary, a sacristy, a choir loft, and a furnace to replace the "round oak iron" stove. In 1963, the church was moved to the Woolsey Street location where an annex was added.

In 1954, the First Communion class poses on the steps of St. Andrews's Catholic Church on East Main Street. Fr. John Kennedy stands with the communicants who are, from left to right, as follows: (front row) Linda Tubolino, Gloria Croyle, Mary Collins, Constance Brennan, Phillip Birch, James Gray, Charles Whalen, and Mark Phillips; (middle row) Nancy Halloran, Dianne Thomas, Theresa Johnson, Marilyn Handy, Phillip Scott, Michael LaFountain, and Michael O'Donnell; (back row) Judy Klock, Kathleen Rau, unidentified, John Ditch, unidentified, John Colin, and Roger Burnet.

The Grace Methodist Episcopal Church, organized in 1831, was served by circuit riders until 1841 when a wooden building was constructed on East Main Street for the cost of $500. After the church was destroyed in the fire of 1899, the congregation chose to rebuild another wooden structure in the same location. In 1942, members voted to combine with the Presbyterian church. The building was sold to the Order of Odd Fellows in 1943; it was destroyed by fire on January 9, 1978.

The Sunday school classes and congregation of the Grace Episcopal Methodist Church pose on the church steps. The bulletin on the right advises "Keep your face always toward the sunshine and the shadows will fall behind."

Seven
MADISON BARRACKS

AERIAL VIEW OF SACKETS HARBOR AND MADISON BARRACKS, N.Y.

The military post called Madison Barracks, named in honor of President James Madison, was established in 1816, following the War of 1812. This 1941 view shows the post at its peak of operation, before it was decommissioned and abandoned on August 31, 1945.

Fort Pike, a water battery on the bluff facing Black River Bay, served as a part of the defense system during the War of 1812. After the war, construction began on Madison Barracks.

This 1842 print by John Barber and Henry Howe shows the Stone Row officers' quarters that were constructed between 1816 and 1819; they are flanked by two rows of soldiers' limestone barracks. These three rows enclosed the parade ground located in the center.

In the Fall of 1816, Col. Hugh Brady, commander of the U.S. Second Infantry, became the first commanding officer assigned to Madison Barracks. His regiment was nicknamed the "Brady's Saints" because they would march from Madison Barracks to the Presbyterian church on West Washington Street to attend Sunday services.

This 1895 photograph of Madison Barracks looks west, showing the original enlisted men's barracks extending toward the lake from the Stone Row (seen on the left).

The limestone buildings, referred to as the Stone Row, were constructed at Madison Barracks between 1816 and 1819 by soldiers of the Second U.S. Infantry for use as officers' quarters. Facing Black River Bay, the two rows of buildings were separated by a sally port, or passageway. Near the roofline of the officers' quarters, facing the sally port, are slabs of stone inscribed on the eastern side with the words "commenced August 1, 1816, completed October 1819," and on the western side "erected by the 2nd Infantry."

In August 1848, Lt. Ulysses S. Grant and Julia Dent were married in St. Louis, Missouri. They arrived at Madison Barracks on November 21, 1848, for Grant's first tour of duty after returning from the Mexican War. According to Julia D. Grant's memoirs, "Sackets was the happiest place in which Ulysses and Julia lived." A second tour of duty with the Fourth Infantry began on January 27, 1851, and lasted until the regiment transferred to the West Coast on June 16, 1852.

The Stone Row was the birthplace of Gen. Mark W. Clark, who accepted the German's surrender in Italy in 1945 at the close of WWII and who signed the armistice that ended the Korean Conflict in 1953. The Stone Row was also the birthplace of Thomas Casey, the engineer who directed the completion of the Washington Monument in Washington D.C. in 1884. Between 1912 and 1916, the Stone Row was home to the many officers of the Third Infantry, including Henry "Hap" Arnold, Walter Krueger, and James Van Fleet.

Built in 1839, the limestone building on the right was the commissary department. In the distance, the large building was the first military post hospital. The smaller building was the bakery.

Built for use as a bakery in 1813, this limestone building was renovated during WWII for use as the noncommissioned officers' club.

This first guardhouse on the post, located to the left of the main gate on Military Road, was photographed by E.II. Boehme in 1867. Soldiers of the Forty-second Infantry, preparing for guard mount, received their orders for the day here. (Photograph courtesy of the Jefferson County Historical Society.)

The new guardhouse was constructed in 1897 at a cost of $5,000. Daily reveille, guard mount, and the evening retreat ceremony were formed in front of the building to march by way of the sally port to the main flagpole on the parade grounds.

The first army post hospital, located on the shore of Black River Bay, is shown in this 1866 photograph. In the 1830s, Dr. Samuel Guthrie discovered the use of chloroform for medical purposes and performed the first operation using this new anesthesia at this hospital. (Photograph courtesy of the Jefferson County Historical Society.)

Dickerson Construction Company of Syracuse built this new two-story brick hospital opposite Fort Pike in 1898. Staffed by the medical department, the hospital was opened for patients in 1899.

In this 1902 photograph, officers of the Ninth U.S. Infantry, stationed at Madison Barracks from October 9, 1892, to April 23, 1905, posed in front of the original barracks. Color-bearer Sgt. John White stands to the right of the regimental standard.

In 1820, the remains of certain soldiers were reinterred in an area behind the Stone Row at Madison Barracks. The remains of Gen. Zebulon Pike, Lt. Col. E. Backus, and Lieutenant Colonel Mills were transported from their original resting place at Fort Tompkins on Navy Point. The remains of Capt. A. Spencer and other soldiers were moved from Fort Pike. The remains of Col. Electus Backus and Col. John Tuttle were brought from a cemetery in Watertown, to be placed with the remains of Brig. Gen. Leonard Covington, Lt. Col. Timothy Dix, and Major John Johnson in the Madison Barracks Military Cemetery, adjacent to Military Road.

In 1908, graves from the War of 1812 were relocated from the Madison Barracks Military Cemetery behind the Stone Row to the village Military Cemetery off Dodge Avenue.

A marble monument, set on a granite pedestal and surmounted with a brass mortar, was commissioned by the U.S. government to honor Gen. Zebulon Pike. In November 1885, the monument was unveiled and dedicated by members of the James K. Barnes Post Grand Army of the Republic. In 1909, the monument was moved to the center of the village Military Cemetery.

This granite monument, in the form of a sarcophagus, was dedicated on May 31, 1888, in honor of an estimated 14,000 unknown soldiers. The inscription on the monument reads " Erected to the memory of unknown United States soldiers and sailors killed in action or dying of wounds in this vicinity during the War of 1812." The monument was moved in 1909 to the Military Cemetery on Dodge Avenue.

Built in 1892, this cut limestone water tower measures 127 feet in height and 26 feet in diameter. It held a 55,000-gallon water tank measuring 65 feet high and 12 feet in diameter. A bronze plaque on the tower lists the Ninth Infantry casualties in the Spanish-American War, the Philippine Insurrection, and the Boxer Rebellion. Use of the stone water tower ended after a more modern steel tower replaced it in 1908.

During the Philippine Insurrection, this bell was used by Filipino natives on September 28, 1901, to signal an attack against the Ninth U.S. Infantry. The bell, from the village of Balangiga in the Philippines, was brought back to Sackets Harbor and placed on a pedestal next to the stone water tower in Madison Barracks. The bell was removed in 1928 and sent to Texas, where the Ninth Infantry was stationed.

This enlisted men's mess hall (dining hall) was built in 1892 at a cost of $38,000. It could accommodate 400 soldiers at one time.

During the winter, troops shoveled snow off the sidewalks between the enlisted men's barracks, in the far distance, and the hospital, not pictured.

107

Looking east from the stone water tower, the officers' quarters extend in a curve with the Commandant's House at the far end.

In the fall of 1894, Capt. Thomas Connell and a detail of enlisted men transplanted maple tree saplings from the Stony Point rifle range to the sidewalk area in front of officers' row.

Built in 1908, this steel water tower, was constructed in the area adjacent to the post military cemetery alongside Military Road.

In 1905, money was appropriated for the construction of double barracks to replace the stone buildings at either end of the parade ground. These barracks extended from the mess hall toward Mill Creek. The Twenty-third Infantry was the first regiment to occupy these quarters.

New barracks were built at the Madison Barracks post beginning in 1905. This photograph, taken on September 15, 1906, shows a local group of workers employed by the U.S. Army to build the barracks.

The dayroom in each barracks was equipped with recreational facilities for soldiers' use during off-duty hours.

Post Exchange and Gymnasium. Madison Barracks, N. Y.

The post exchange was built in 1905 at a cost of $8,000. It contained a gymnasium, a library, a bowling alley, a restaurant, a barbershop, a Red Cross office, a taproom, and a store.

Members of the Third U.S. Infantry stand in formation next to the post exchange. This unit was stationed at the barracks from 1912 to 1916.

Commanding Officer's Quarters Madison Barracks
Sacketts Harbor, N. Y.

In 1906, Col. Philip Reade, commander of the Twenty-third Infantry, was instrumental in securing appropriations for the construction of the commanding officers' quarters, located at the northeast end of officers' row.

Members of the Twenty-third U.S. Infantry are pictured in front of their barracks. They were stationed at Madison Barracks from 1905 to 1908.

The Twenty-fourth U.S. Infantry was stationed at Madison Barracks from 1908 to 1911. Members of the Twenty-fourth were part Company I, Company L, and Company K. This formal photograph was taken by the Huested Studios. Mr. Herbert Huested Sr. had a photography shop in Sackets Harbor; his son Richard had a photography shop in Watertown.

Facing Military Road, a row of five brick duplex buildings provided housing for noncommissioned officers and their families.

After WWI, the Madison Barracks post was used as a convalescent hospital for soldiers wounded in the war. The barracks were connected with a series of covered corridors.

On July 7, 1917, artillery students of the Second Field Artillery New York National Guard from Brooklyn received their first instruction with field guns at Madison Barracks.

A detail of men from the Seventh Field Artillery is shown delivering manure from the horse stables at Madison Barracks to gardens in the village.

At Madison Barracks, horse shows and polo games were a popular source of entertainment for military personnel and village residents. Officers who owned their own horses often participated in both the shows and the games.

117

During the years 1922 to 1934, the horse-drawn Seventh Field Artillery unit was stationed at Madison Barracks. Three gun sheds were constructed near Mill Creek to provide storage for field artillery pieces.

Three stables were constructed to accommodate the 150 horses assigned to each battery of the Seventh Field Artillery. The horses were used to haul the caissons (ammunition wagons) and artillery pieces.

This two-story wooden building was constructed in 1887 at the entrance of Gate No. 1. It housed the official headquarters of the Eleventh U.S. Infantry, commanded by Col. Richard I. Dodge. Included on the main floor were a library and military schoolroom. The second floor, called Dodge Hall, provided a dance floor and seating for silent movies. The structure was destroyed by fire on April 19, 1932.

The Post Theater—a single-story, waterfront building—was completed in 1932. It had a seating capacity of 398. At the dedication ceremony, the film program included a newsreel, a Mickey Mouse comedy, a musical comedy short in Technicolor, a sportscast, and the full-length movie *Pack up Your Troubles*, which featured Laurel and Hardy. The chaplain's office was on the right of the main entrance; an annex of the post exchange was on the left.

The post headquarters housed offices for the commanding officer and his staff. A stage and a large ballroom on the second floor provided space for the entertainment of the officers. Officers held dances with music by military orchestras, had special parties, and hosted visiting dignitaries in the ballroom.

The Twenty-eighth U.S. Infantry poses in front of Company D headquarters. This unit was stationed at Madison Barracks from 1925 to 1931. On the left is Capt. George R. Kelsch, who enlisted in 1898. He retired at the close of WWII. Lt. William J. Verbeck, who later became a major general and superintendent of West Point, stands in the front row on the right.

This formal photograph shows members of the Third U.S. Infantry Quartermaster Band in front of their quarters, which was located at the far eastern end of the enlisted men's barracks. They were stationed at Madison Barracks from 1912 to 1916. Their director was George Fairleigh. M.H. Schneider played trombone; W. Ross was the drummer.

The launch docked at the Madison Barracks pier was used to transport food and ammunition supplies to the Stony Point rifle range on the shore of Lake Ontario. Troops marched the 13 miles from Sackets Harbor to the range for target practice.

Enlisted men of the Twenty-eighth U.S. Infantry practiced firing machine guns into the limestone cliffs that form the shoreline along Madison Barracks, just below where Fort Pike was located.

This c. WW aerial view shows the enlisted men's permanent barracks. Notice the temporary barracks on the right.

122

On July 5, 1930, a bronze plaque to honor WWI casualties of the 1917 Officer's Training Class was unveiled. Brig. Gen. William Sample, recipient of the Distinguished Service Medal and commandant of the first class, gave the address at this presentation.

In 1934, the Madison Barracks Fire Department received a new fire truck. Qualified enlisted men served as firefighters.

The Reserved Officers' Training Corps (ROTC) from Cornell, Princeton, and St. Bonaventure used this tent area adjacent to the mess hall as quarters during summer training in the 1930s.

Cement block structures were constructed in the 1930s for use as a mess hall and latrines during summer training by ROTC. Citizens Military Training Camp (CMTC) also utilized the structures.

The Madison Barracks Ninth Division of the Twenty-fifth Field Artillery, on maneuvers at the Pine Camp artillery range, prepare to fire a 75-millimeter piece of artillery. In 1906, the area of Pine Camp near the communities of Black River and Deferiet was selected by the commanders of Madison Barracks for their army maneuvers. After WWII, Pine Camp was renamed Fort Drum.

A unit of the First Division Fifth Field Artillery, stationed at Madison Barracks from 1931 to 1940, practices live firing at Pine Camp (Fort Drum).

Civilian employees of the quartermaster department provided maintenance of the military facility. Shown here, from left to right, are as follows: (front row) Charles Gamble, "Frenchy," unidentified, Richard McGrath, Mrs. Londerville, and Mrs. Frances Youell; (back row) Mr. Zeller, Mr. Arthur Hamel, unidentified, Ray Bailey, John Gunnison, Mr. Dunn, James Grinnel, Charles Ward, Charles Smithers, Bernard Orvis, Patrick Brennan, Henry Contridorff, and Albert Gonzales.

In the 1940s, the 258th Artillery from New York City arrived at Madison Barracks to replace the regular troops. They are shown here passing in review in front of the original mess hall.

In the early 1940s, soldiers and officers of the 258th Field Artillery from the Bronx Kingsbridge Armory stand at attention in front of the Stone Row as the retreat ceremony is conducted.

At 5:00 p.m. each day, a retreat ceremony was conducted, with the lowering of the garrison flag at the main flagpole on the parade ground. A cannon salute was fired as the bugler, at the megaphone, sounded retreat. In the background, from left to right are the post theater, the post headquarters, the post Exchange, and the enlisted men's barracks, c. 1940s.